D1142250

Ireland
PAINTED

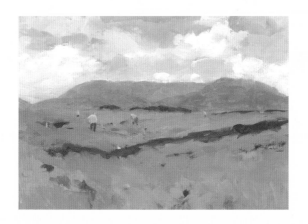

MARIE HENNESSY

THE O'BRIEN PRESS
DUBLIN

First published 2007 by The O'Brien Press Ltd.
12 Terenure Road East, Rathgar, Dublin 6, Ireland.
Tel: +353 1 4923333; Fax: +353 1 4922777
E-mail: books@obrien.ie
Website: www.obrien.ie
ISBN: 978-0-86278-957-2
Text and paintings © copyright Marie Hennessy 2007
British Library Cataloguing-in-Publication Data
Hennessy, Marie
Ireland painted
1. Hennessy, Marie 2. Ireland - In art
I. Title
759.2'915

1 2 3 4 5 6 7 8 9
07 08 09 10 11

Editing, typesetting, layout and design
The O'Brien Press Ltd.

Printing: KHL Singapore

DEDICATION
To my mother

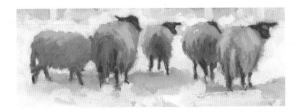

ACKNOWLEDGEMENTS
My thanks to The O'Brien Press, with special thanks to Íde Ní Laoghaire and Emma Byrne for their eye and their interest. My thanks also to generous patrons who made works available for this publication.

CONTENTS

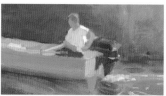
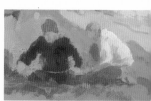

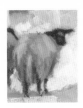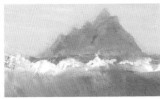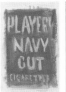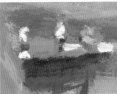

CATTLE, CASTLEGREGORY
Co. Kerry

Cattle are a familiar sight all over Ireland. They never hurry and seem to slow time down in some wonderful sort of way. Their peaceful presence graces our green pastures, or, as in this case, a tract of marginal land skirting the edges of the beach. The cow is an important theme in Irish literature and folklore – the most famous example being the story of the Táin, which tells of a great cattle raid by Queen Medb and her armies. In stealing the prized Brown Bull of Cooley, Medb becomes as powerful as her husband. However, two bulls can not occupy one field and following a fierce fight, both lie dead.

Today, cattle-farming is still central to the Irish way of life, providing our tables with the very best beef, butter, cream and cheese, and the sight of a fine herd grazing in a field is a pleasure to the dairy-farmer and passer-by alike.

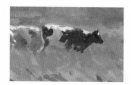

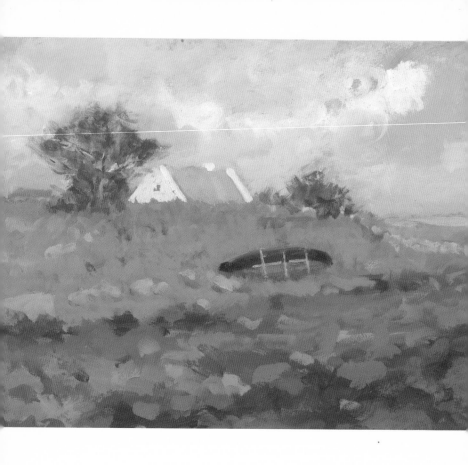

COSTELLOE, CONNEMARA

With so many roads skirting the shoreline in Ireland, we might come across a quiet cove such as this in any number of coastal counties. Yet, the upturned currach and the white stone cottage leave us in no doubt that we are in Connemara. The currach is a descendant of the ancient skin boat, when animal hides were stretched over a wooden framework. Today the skin has been replaced by waterproofed canvas, and the long, elegant oars are often assisted by the power of an outboard motor. The currach moves swiftly over the surface of the water, its distinctive black shape always visible amid the surf and the green-blue sea. On this particular afternoon, no fishing was being done: the tide was out and the currach lay upside-down, staying dry on its wooden posts.

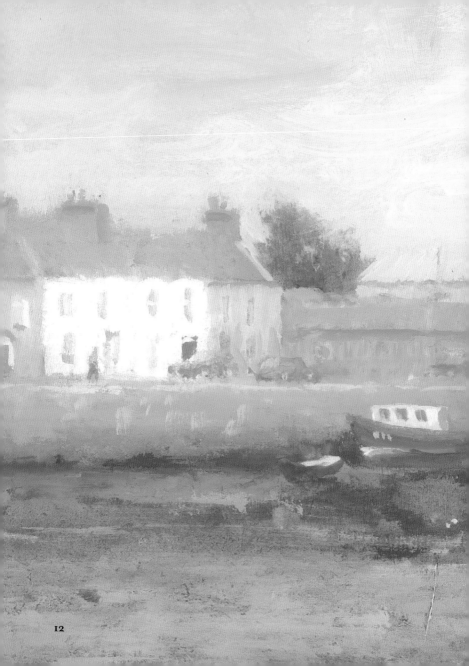

LONG WALK, GALWAY BAY

The houses along the quay known as Long Walk stand close together in a quiet line as if caught in a perpetual state of bidding farewell to the Corrib, as this is where the river ends and its waters flow into Galway Bay. This area faces the old Claddagh region of the city, at one time a fishing village of closely built, white-washed cottages. Even if you're not lucky enough to see the sun go down over the bay, there is still much to enjoy — elegant swans, squawking gulls, fresh salty air and endless flowing waters, but mostly the quiet ghosts of an older Galway.

THE CLIFFS OF MOHER
Co. Clare

On the coast of Clare the majestic cliffs of Moher rise from the sea, reaching 230 metres at their highest point. Over three hundred million years ago rivers flowing in this area dropped great sandy deposits which, in time, solidified, thus creating the stratified rock face we see today. The name Moher was taken from the nearby ancient fort of Mothar, which was replaced during the Napoleonic era by the signal tower now on the site.

One of the folk tales associated with the Cliffs of Moher tells the story of Mary McMahon or Máire Rua (red-haired Mary), a lusty local landowner who disposed of unwanted suitors by daring them to gallop their steeds to the edge of the highest cliff. Seeing the drop, the frightened horses would rear up and throw their mounts headlong into the sea. There are many other stories told of Máire Rua, including that she kept a male harem disguised as maidservants. However, these stories are likely to have little truth and much embellishment – the Irish imagination is never found wanting when it comes to elaborating on the details of a fine tale!

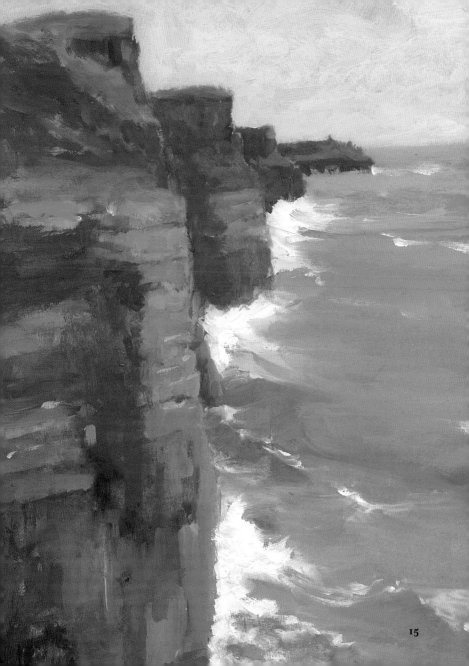

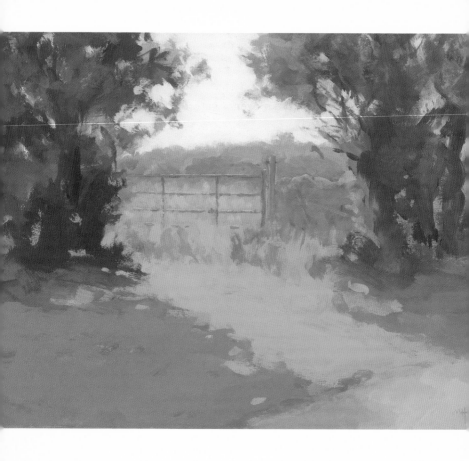

THE RED GATE
Co. Kilkenny

When a farmer looks over a gate it may be to check the animals in the field or a crop in one nearby. The casual passer-by, on the other hand, might admire the view or notice the light. Consciously or unconsciously all Irish people are connected to the land. The field is a central image in our literature, which is hardly surprising since we have fought, lived and died for these plots. The land has been the means of our survival and while the gate may be simply a way of keeping animals in, it is also a powerful symbol of ownership.

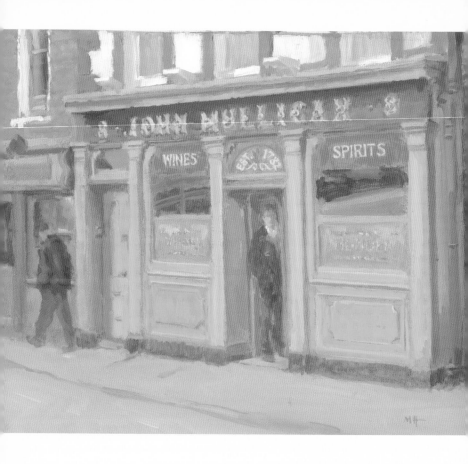

MULLIGAN'S PUB
Dublin

Mulligan's pub is about half way down Poolbeg Street, a short street close to the river Liffey on its south side. Light catches the gold leaf on the name-board and window signs, as the pub is located on the sunny side of the street.

It is said that the best pint of Guinness to be had in the city is at Mulligan's, where the pulling of a pint is raised to the level of an art form. To ensure the most satisfactory result, the glass must be held at an angle — 45 degrees is regarded as the optimal tilt. The next step in the process is the slow filling of the brew, to be accomplished in a calm and unhurried manner, no matter how full the house or how thirsty the drinkers. A rich, creamy head tops off the perfect pint — nourishment for both body and soul to generations of Irish drinkers.

Part of the charm of Mulligan's is that it was never modernised — it looks much as it did in the time of James Joyce. Indeed, several of Joyce's characters found solace in Mulligan's, mingling fiction with reality to conjure up the Dublin of his day. Over the years, the great and the small have rubbed shoulders here — John F. Kennedy among them.

THE ASSEMBLY ROOMS
Cork

Built as the result of a dispute, perhaps the Assembly Rooms on Cork's South Mall were destined from the outset to be unloved. The row occurred when an ex-priest with anti-Catholic attitudes was refused permission to lecture at the Athenaeum, later the Opera House. Outraged Protestants, in defence, built their own hall. Initially functioning as a Protestant hall, later it became a cinema and opera house, then a coffee shop, and latterly the premises of a housing agency. The building was designed by Richard Rolt Brash in the mid-nineteenth century. Its pleasing proportions and decorative detail make it an architectural gem, a delight for the passer-by — if only they would notice!

ASSEMBLY ROOMS

21

ROUGH SEA NEAR BLACK HEAD
Co. Clare

As we leave Ballyvaughan and head towards Doolin in County Clare, the Galway coastline remains visible in the distance; the road begins to wind through the rocky terrain known as the Burren. This is a region of bare limestone, spreading across most of north west Clare. The entire area was once under water, but then the sea receded, exposing the fissured limestone with its characteristic clints and grikes. There is little soil here and the rocks seem like the very bones of the earth laid bare. Depending on the light, the Burren landscape can look grey or pinkish white, its stark beauty unmatched anywhere else in the country.

As the road winds towards Black Head, large boulders on the left draw the eye upward, while flat slabs dip towards the sea on the right, darkening where they touch the water. A lighthouse warns boats to steer clear of the rocks, but for those on land, getting close to the edge is what excites, and so we confront the danger for the exhilaration of crashing waves and white foam sprayed high into the air.

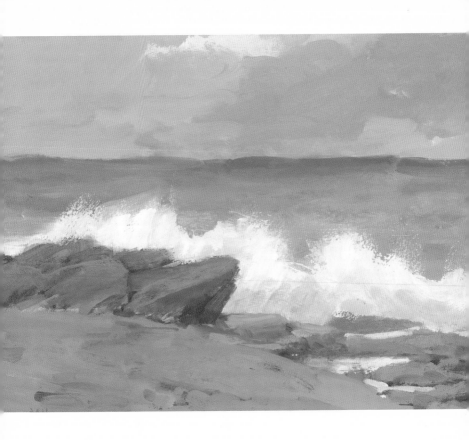

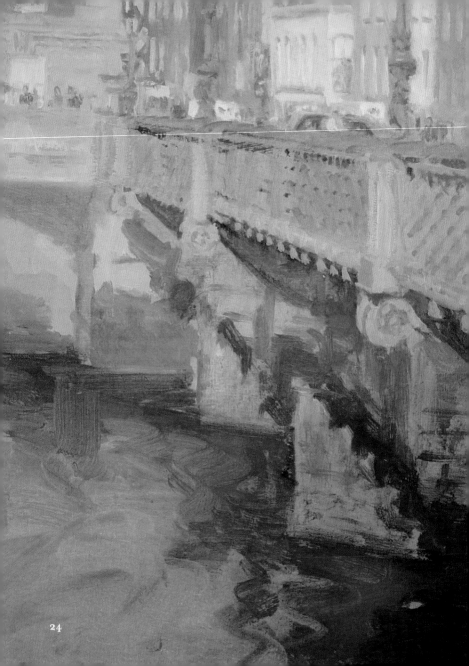

24

GRATTAN BRIDGE
Dublin

The green-painted, cast-iron metalwork of Grattan Bridge gives this Liffey crossing a particular charm, especially on sunny days. Looking north we see Capel Street; looking south our eye follows the gentle rise of Parliament Street taking us up towards City Hall. The bridge was opened in 1874, one of the first initiatives of the Wide Streets Commission who broadened many of Dublin's streets. To create the generous pavements on this bridge, metal supports had to be extended from the stonework below, but a feeling of lightness is achieved by the criss-cross lattice of the metal structure. The bridge's lamp standards are decorated with playful little sea horses, back to back, daring the passer-by to smile.

Grattan Bridge once offered an excellent vantage point from which to see the upper and lower quays and the city's skyline silhouetted in dramatic evening light. However, a new initiative by the city planners in 2004 set up mini market kiosks on the bridge and alas these unimpeded views are now gone.

THE ROCK OF CASHEL
Co. Tipperary

Rounding a bend in the road and catching that first glimpse of the Rock of Cashel is an unforgettable experience. Once the seat of the Kings of Munster, the earliest structure is the round tower, followed by the romanesque church known as Cormac's Chapel. The later gothic cathedral, with its partly ruined nave and tower, are more clearly seen in the painting here. It is difficult to do justice in words or paint to the Rock of Cashel. There is something about it which remains permanently elusive: perhaps it is the pull of opposites that gives it its particular fascination — on one hand strong, permanent and immovable, yet shimmering and radiant.

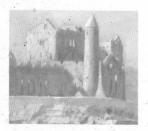

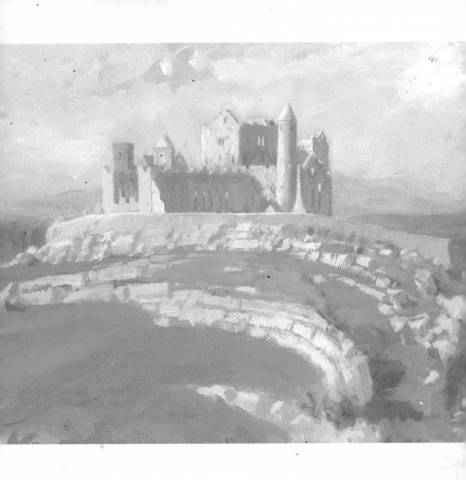

MWEELREA MOUNTAINS
Co. Mayo

Travelling from Louisburgh towards Roonah Lough, a narrow side-turning leads to Carrownisky beach. Standing with the sea behind us we face south towards the Mweelrea mountains. Sunlit clouds hurry across the open sky but the mountains are as rooted and permanent as time.

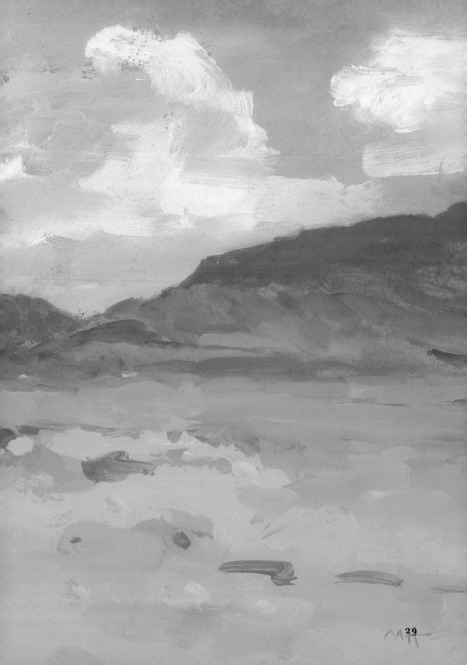

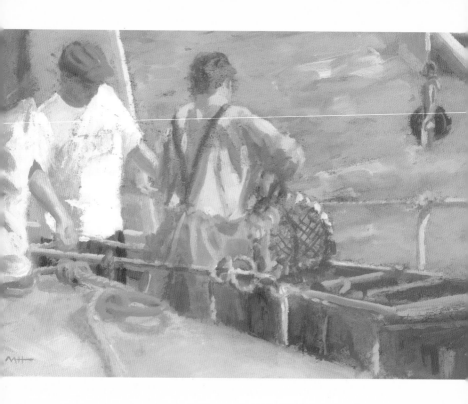

FISHERMEN AT CASTLETOWNBERE
Co. Cork

Castletownbere has one of the world's largest natural harbours and so it's hardly surprising to find that fishing is the very heart of life here. Fine specimens of crab and lobster are taken from these waters, but also a wide range of white fish such as plaice, pollock, brill, cod, sole and, of course, the delicious monkfish.

Today Castletownbere is the largest town on the Beara peninsula. Its expansion was helped in the nineteenth century by the development of copper mines at nearby Allihies.

Life on the pier is filled with colour and activity as boats are prepared for fishing trips and unloaded on their return.

MENDING NETS,
HOWTH HARBOUR
Co. Dublin

The area known as Howth lies north of Dublin city, a hilly peninsula jutting out into the sea but remaining connected to the mainland by the sandy isthmus of Sutton. The existing harbour, with its twin piers and handsome granite lighthouse, was completed in 1818, although Howth had established itself as a port as far back as the fourteenth century.

Today the fishing fleet berths on the west pier. Trawler men, fishmongers, seafood lovers and gulls mingle easily, and mending nets is all part of a day's work for fishermen. The east pier is where most people walk, heading for the lighthouse — some at speed, others strolling along enjoying an ice cream from Ann's shop. This pier is open to the sea and great waves wash over its central section on stormy days.

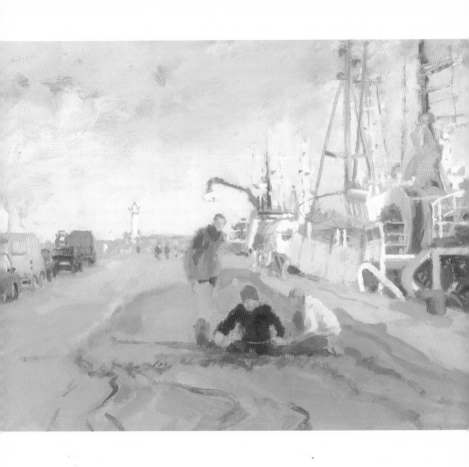

TROOPERSTOWN WOOD
Co. Wicklow

On the island of Ireland one is never more than 120km from the sea. Inland there are freshwater rivers, lakes and canals, so, whether in pursuit of serious fish or just seriously fishing for minnows, the waters of Ireland offer many options. Here in Trooperstown the scene is perfect, with water shallow enough to be safe and stepping stones to help you cross — or to park your bucket, if that's what's needed.

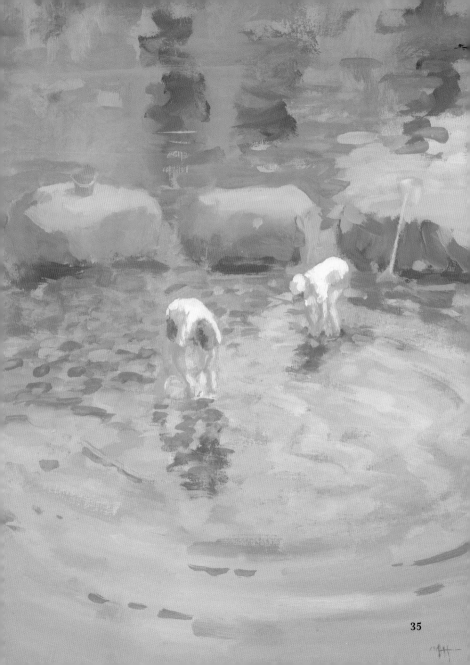

TURF-CUTTING
Co. Mayo

Great tracts of Ireland are covered by blanket bog.
Beneath this, peat can go to a depth of three metres. Peat,
called 'turf' when cut, has been used as a fuel source for
many years. A skilled cutter will work at speed, using a
special spade or *sleán*. He will first strip back the upper
growth, then cut the turf below into uniform chunks or
'sods', leaving a clean, evenly cut turf bank. The sods are
built into stacks for drying, later to be transported home
for burning.

Here, near Ballycastle in north Mayo, local men head across the bog to the annual turf-cutting competition. Each competitor is assigned a tract of bog and judged according to the principles described. The partakers are usually male, although a few brave women have tried their hand. As world fuels run out, maybe many of us will learn to wield the *sleán*. There is, however, a fine balance to be struck between the need for fuel and the protection of the natural environment and overcutting, especially by machine, has left the landscape decimated in some places.

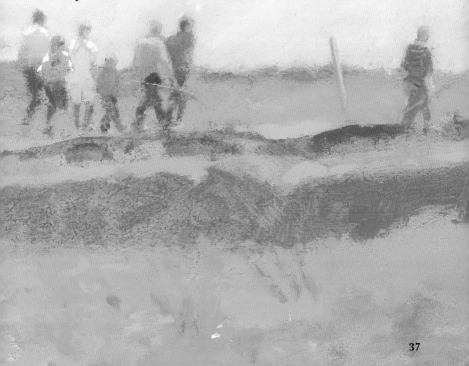

GUINNESS'S GATE
Dublin

The pungent smell of hops and roasting barley wafts around James's Street and we know we can't be far from a brewery. Established in 1759, the Guinness Brewery occupies an extensive site at St James's Gate. The church of St James still stands, although the old city gate is long gone — these two structures combined to give the area its name. The main entrance has a cut-stone arch and two side entrances. It is Victorian in style, the result of modifications made around the middle of the nineteenth century. To the left is the former Guinness home, also given a Victorian makeover around the same time.

Arthur Guinness chose the most recognisable Irish emblem, the harp, as a mark of distinction for his stout. The well known buff labels, stamped with the harp above and Arthur's signature below, have been in use since the foundation of the brewery. Two hundred and fifty years of success means that the Guinness brand is recognised the world over, so much so that today that black pint glass with its white rim may have overtaken the harp as the foremost symbol of Ireland — an irony which would surely bring a smile to Arthur, wherever he is.

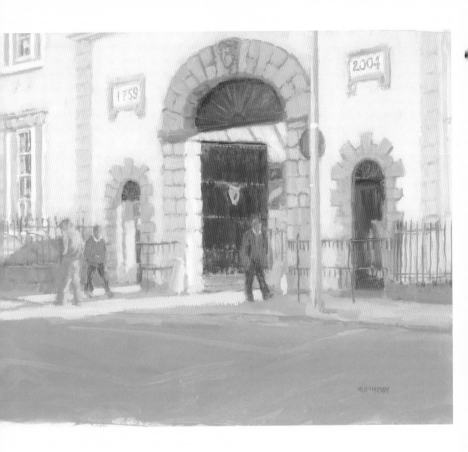

39

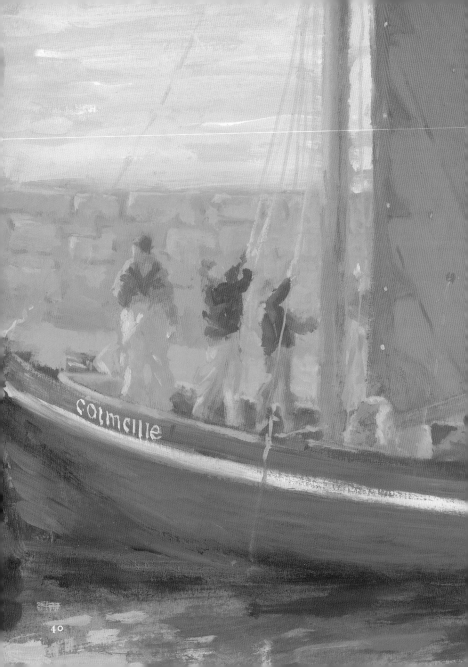

colmcille

RAISING THE SAIL
Co. Galway

As the red sail of the Galway Hooker is raised, a clamour of voices comes up from the pier. It's a wet day in Lettermore and the boat is ready to sail. Hookers came into being in Galway during the eighteenth century. Shaped with an outward curve, they sit steadily in the water and so make perfect cargo boats. Their main function was as carriers, travelling between the mainland and the islands off the Galway coast. In variations of black and red, their unique sail formation consists of a central mast, a main sail and two foresails. Modern boats may be faster, but are rarely more beautiful.

SHEEP IN THE SNOW
Co. Monaghan

January snow — and a group of sheep make the best of it in a Monaghan field. Their thick winter coats keep out the cold. In due course this same wool will be shorn, spun and made into clothing to keep us humans warm. Seen in a green field, sheep look creamy white, but against snow they are not so lovely — still, few of us look our smartest in winter! The black-faced sheep is common throughout Ireland, with the horned variety confined mostly to the west of the country. Even in the harshest conditions sheep eek out something to nibble on, and this little group seems resigned to the winter conditions, if a little curious about who might be observing them.

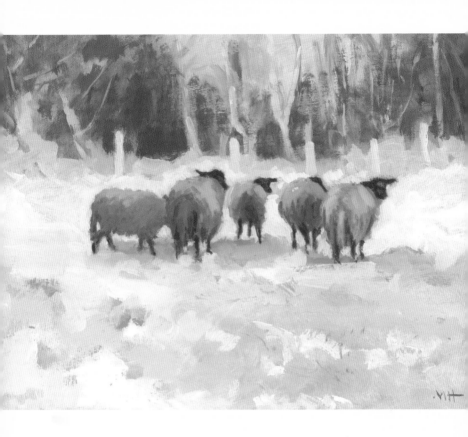

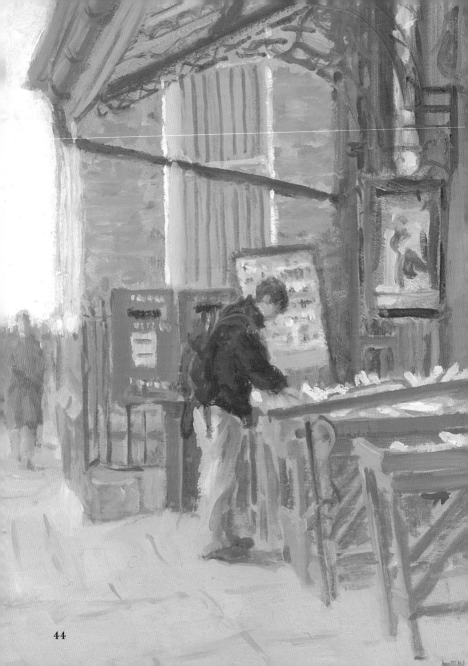

GREEN'S BOOKSHOP
Dublin

Small, individual shops like Green's of Clare Street hold a particular attraction. There is always the possibility that you'll find something special – and even if you don't, the search itself will be rewarding.

Antique barrows stand on the pavement outside, inviting the passer-by to stop and browse. Above them the elaborate Victorian canopy and sign-boards are virtually unchanged since the shop began trading in 1843. The names of many writers who rummaged through the bookshelves at Green's now adorn the covers and spines on these same shelves. Life brings changes, yet this shop has managed to hold on to much of its past. A fireplace in the upstairs room suggests the comforts of yesteryear: this is where staff once fried their sausages, drank their tea and looked down on the street life below. From these windows you could see Oscar Wilde's childhood home, No. 2 Merrion Square, today the American College.

Green's is a Dublin landmark, perhaps one we take for granted, but without it the city would lose something more than a shop.

UNDER THE ARCH
ON THE RIVER BARROW
Co. Carlow

The lower stretches of the river Barrow flow serenely through counties Carlow and Kilkenny, with some of Ireland's richest farmland on its banks. But the river has its own wealth to offer in the form of bream, brown trout, eel, pike and the prized wild salmon. Walkers too will find much pleasure here. What is popularly known as the Barrow Line offers miles of accessible riverside pathway, with locks and weirs to enjoy along the way.

This bridge, built by Ralph Gore in the 1760s, was once the scene of a battle, but now in pure tranquillity a boat and its two fishermen are carried gracefully beneath the second arch. The bridge is at Goresbridge, and marks the border between the counties of Carlow and Kilkenny. Locals have always accepted the centre of the bridge as the exact dividing line, thus generations of village children proudly boast of being able to stand with a foot in Carlow and a foot in Kilkenny at the same time.

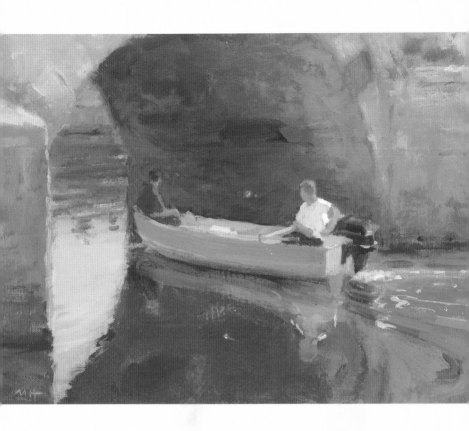

CROAGH PATRICK
Co. Mayo

Croagh Patrick viewed across an expanse of landscape is always recognisable. Whether looking towards it from north or south Mayo, its unmistakable pyramidal shape draws the eye. Striking, solid and strongly anchored to the earth, this sacred mountain has long been a place of worship for pagans and Christians alike. The last Sunday of July marks the day of annual pilgrimage when thousands of walkers climb Croagh Patrick to confess and pray on its misty summit.

POTTINGER'S ENTRY
Belfast

Pottinger's Entry is one of the five oldest streets in Belfast. Named after Sir Henry Pottinger, who became the first governor of Hong Kong in 1843, this alleyway is in the heart of old Belfast, linking High Street with Ann Street.

Along these 'entries' or passageways connecting the more prominent streets, are some of the city's best-loved Victorian pubs. Pottinger's Entry is home to The Morning Star, a pub with its own interesting history as it was once the coaching house for the Belfast—Dublin mail coach.

All of life seems to pass through this entry as summer T-shirts give way to winter mufflers — and the city councillors agree that it should have a facelift once again.

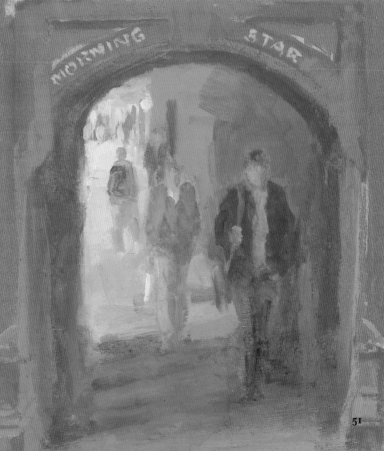

POTTINGER'S ENTRY

MORNING STAR

Bar
&
Lounge

51

HOOK HEAD LIGHTHOUSE
Co. Wexford

Believed to be the oldest operational lighthouse in Europe, Hook stands monumentally above the craggy rocks and deep green water. It was built in 1172 and modified in 1791. At an earlier period the site was in the keeping of monks, followers of St Dubhán, and it is said that as far back as the fifth century beacon fires were lit here to warn boats away from the hazardous rocks. Hook's sturdy tower of black and white bands epitomises endurance, standing steady against the heaving waters of the Celtic Sea.

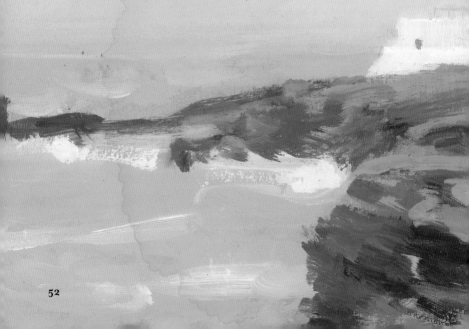

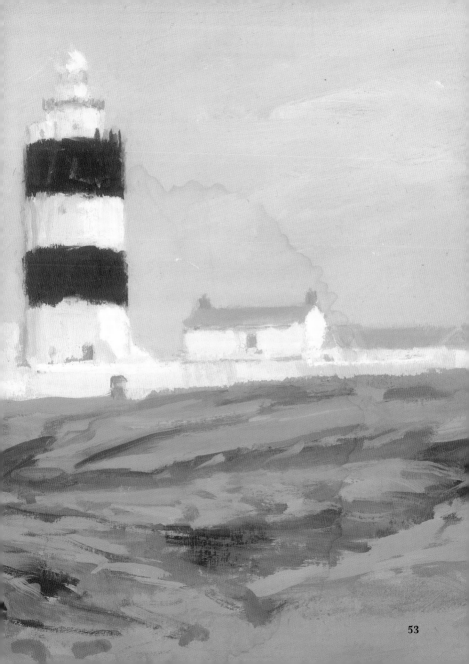

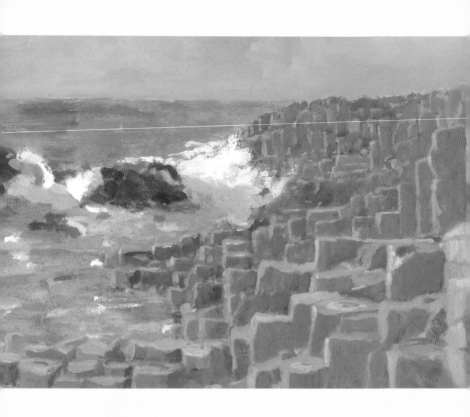

THE GIANT'S CAUSEWAY
Co. Antrim

Protected as a world heritage site, the magnificent causeway is a natural wonder, with its thousands of basalt columns massed together, some as high as twelve metres. These multi-sided columns were formed over sixty million years ago when volcanic lava cooled especially quickly in the sea water — though folklore offers us a more colourful explanation, claiming that it was built by Fionn mac Cumhaill, the legendary Fianna warrior, who allegedly travelled by foot across to Scotland to challenge his enemies!

KERRY FARM

Many of us are aware of the seasonal patterns of farmwork. We may notice the earthy beauty of ploughed fields in winter or the gold of ripening barley in the summer months. Then there are lambs in spring and cattle grazing every last blade of grass during the growing season.

However, farming patterns are changing. Today, as specialisation and intensification increase, even the age-old practice of pasture-grazing is giving way to new methods and cattle are fed on pre-prepared dried foods. Farms facing the greatest threat of extinction are the small holdings of mixed farming which predominate in the west of the country. Here in Kerry, a traditional farmhouse sits comfortably between the rise of the mountains behind and the foreground turf bog.

Such scenes and the cyclical rhythms of farm work may regrettably become a thing of the past.

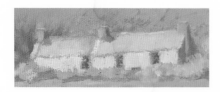

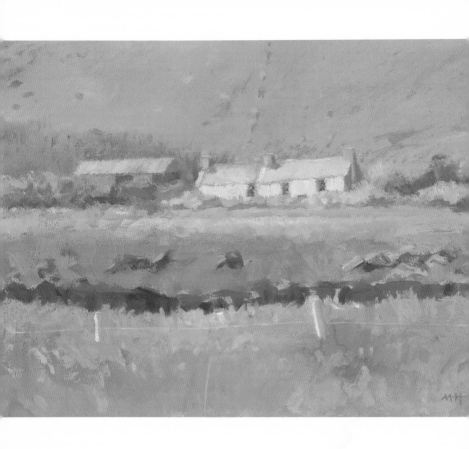

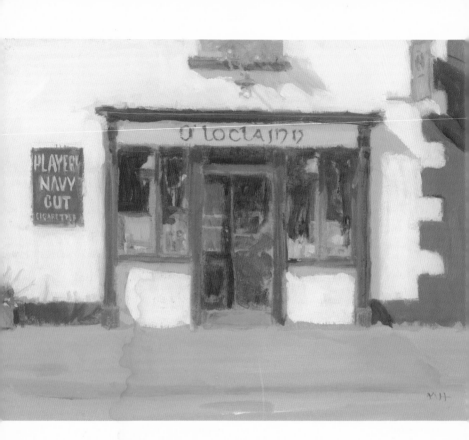

TRADITIONAL PUB, BALLYVAUGHAN
Co. Clare

The art of distilling whiskey was introduced to Ireland by the monks of the middle ages, which may explain why we Irish embraced religion with such zeal. A small village can have as many as six or seven pubs and not be considered unusual. However, it would be a mistake to see the pub merely as a place for drinking. This is where we talk, tell our stories, laugh, listen or simply contemplate. But, of course, we do all these things better with a drink.

Traditionally the pub was a meeting place for men only, a tradition which faded away over the second half of the twentieth century. Until relatively recently this village pub in Ballyvaughan operated according to the old custom. Thankfully, today women too can enjoy a drink here and savour the charm of its old-world atmosphere.

THE BUTTERSLIP
Kilkenny

A narrow lane with rising steps leads to Kilkenny's main street. This lane is known as the 'Butterslip' since it was here that butter makers came to sell their produce on market days.

Kilkenny offers much to those with an interest in history. Near this lane is the small, but well preserved tudor building known as Shee Alms House. Further away, at Irishtown, there is St Canice's, a perfectly preserved thirteenth-century gothic cathedral. And on the Parade is the great Norman castle of the Ormonds, now beautifully restored; its battlements and towers stand high above the river Nore, making it the jewel in Kilkenny's crown.

The city's narrow streets bustle with life, and opposites are woven together in some magical sort of way – past and modern, busy and relaxed. The inhabitants walk up and down the main streets, not so much for the purpose of shopping as that of meeting and greeting.

In the sporting arena, Kilkenny's hurlers have few equals. Hurling is in the very air, and even on the shortest walk around the city one will invariably catch a glimpse of that distinctive Kilkenny stripe – the black and amber.

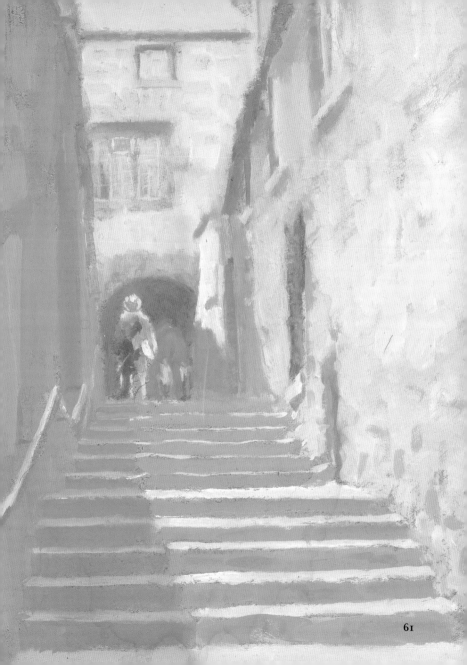

THE FEATHERBED
Co. Wicklow

A ridge of mountainous terrain merges Dublin into Wicklow on its south side. Climbing slowly from Rathfarnham or Tallaght, the richer vegetation gives way to moorland along the winding length of the Military Road. There are no trees at these altitudes, just low-growing ground cover, giving the landscape a soft appearance. The area is known as 'The Featherbed'. In Joyce's *Ulysses*, Molly Bloom recalls a long 'joult' over this mountain on a gorgeous winter's night. That such wildness exists so close to the capital city is a particular delight.

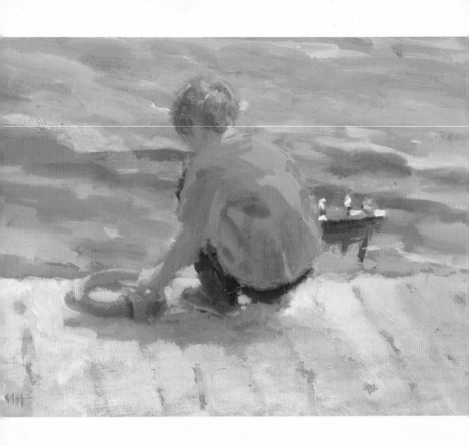

BOY WITH A BOAT
Co. Cork

Here a young boy plays with a toy boat. It's holiday time and during long summer days imagination has free reign. Electronic toys would find it hard to compete with the lure of water and the fluid movement of the simple wooden boat. On this pier in Castletownbere, fishermen make ready real boats just a short distance away. There is noise, there is clamour, it's high summer — time for light, colour, the outdoors and hours of play.

ST FINAN'S BAY
Co. Kerry

This small cove is surely one of the most beautiful places in Ireland. Part of St Finan's Bay, it is situated at the end of the Iveragh peninsula. On the horizon is the distinctive shape of the Little Skellig, the first of two rocky outcrops off the coast. Lying behind, somewhat eclipsed in this painting, is the Great Skellig or Skellig Michael, the site of Ireland's most dramatic monastic settlement. Here, at the western edge of Europe we look out on the Atlantic ocean, its waters rolling to the shore in great waves. Light dazzles, the air has a particular freshness and on a sunny day the feeling is one of pure exhilaration.

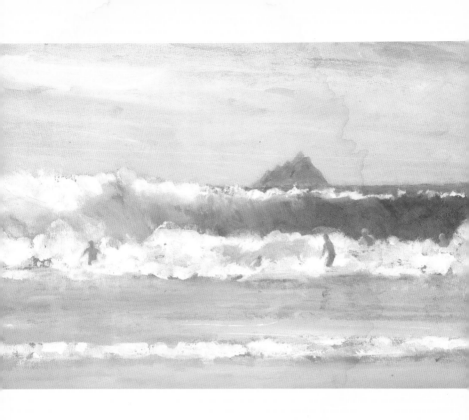

A Note from the Artist

Most of the images included here have been painted recently — this is an Ireland that still exists, although the changing nature of things is especially clear to anyone who is in the constant process of looking. Unfortunately, I have had the experience of seeing places disappear before my eyes, with the developers at work while the paint was still wet on the surface. But for all that, the Ireland of small, irregular fields with hedgerows and grazing animals remains. Turf-cutters continue to work on the bogs, people chat in local shops and small trawlers sail out from our harbours each morning in search of the daily catch. As for the Irish bar! Well, it more than survives both here and abroad, having established itself in many of the world's major cities.

Over a period of time artists evolve a method of working which best suits them. I particularly like to use oil paint on paper as its smooth surface facilitates the touching in of highlights unhindered by the

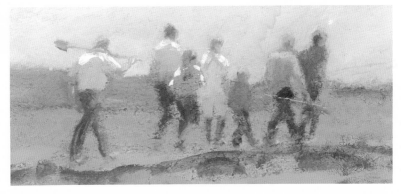

irregularity of canvas weave. Working on a small scale, it's possible to add tiny dots of light in just the right places, and this makes all the difference to the finished piece. Oil paint and paper may seem incompatible, but artists have worked with this combination throughout the centuries. For example, Constable produced many such paintings and, not only are they still intact, but two hundred years later they have a wonderful freshness. It is, of course, necessary to use good-quality art paper prepared with several coats of glue size followed by further coats of gesso (gypsum primer). The process is similar to that of canvas preparation.

Before starting to paint I usually apply a wash of diluted tan-coloured oil over the entire surface. Look closely at any of the paintings reproduced here and you'll see this underpainting coming through. Working on a toned ground was standard practice in European painting until the mid-nineteenth century when the

Impressionists began working directly onto white. My preference for a coloured surface is that it acts as a kind of mid-tone against which the bright shades seem brighter and the darks darker. It also has a unifying effect as the tan flickers through the upper

layers of colour and seems to pull the piece together into a more coherent whole.

How the day feels is always important to me, especially when I'm painting. There is an awareness of weather, visibility, the time of day, the light. Intangible and less visible elements of atmosphere and air are essential to landscape and usually registered through paint-handling. Quick, fluid strokes suggest the movement and flux of nature. When painting cloudy skies the subject is constantly moving, often with very bright and dark areas side by side. I work swiftly, because brushmarks that are rapidly made catch the immediacy of the moment and bold, direct marks retain a liveliness in the paint. The objective is always to capture the event without overworking the paint. As for the grey skies we in Ireland complain so much about — they offer constant drama and colour, and our cloudy skies are rarely devoid of warm tones.

The figures in my paintings are mostly small in scale and go about their business unaware of being observed. I don't consider myself a figure painter as such, but I like that extra dimension that figures bring. They create their own small dramas, but, in particular, they suggest the human activity associated with place.

Ireland has changed and is continuing to change — within a short time-span there is much that is new. Perhaps this is all the more reason for us to keep one eye on our past lest we lose that connection with what we've come from: the land, the towns, the cities, a way of life, all those things that make us unique, the things that define and mark our difference.